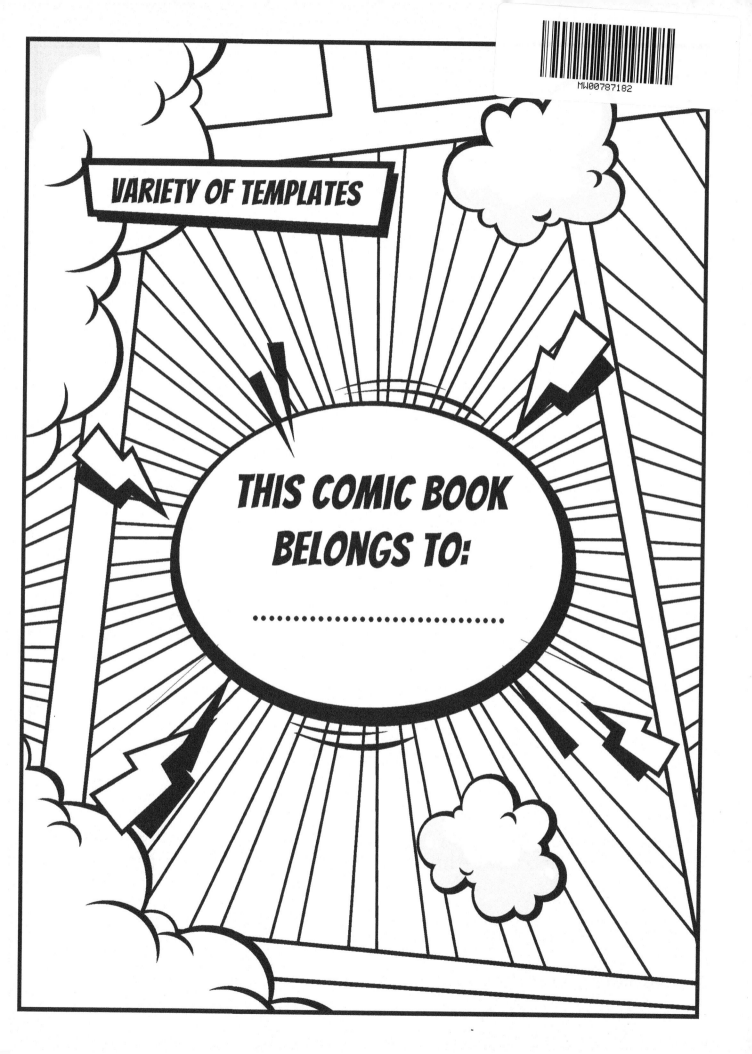

www.fairylandbooks.com

Thank you for your purchase!

We're thrilled by your recent purchase of our comic book at Fairyland Books! Your support means the world to us as we embark on this imaginative journey together. We believe in the power of storytelling to unite families, providing a limitless space for creativity to thrive. Through our comic book, families can weave tales, fostering communication and strengthening bonds. Children develop vital skills, embracing creativity and individuality. With quality time spent away from screens, families create cherished memories filled with laughter and connection. We're grateful for your choice to inspire creativity and storytelling in your family.

We can't wait to hear about the incredible adventures you'll embark on together!

Your review would be greatly appreciated.

WWW.fairylandbooks.com

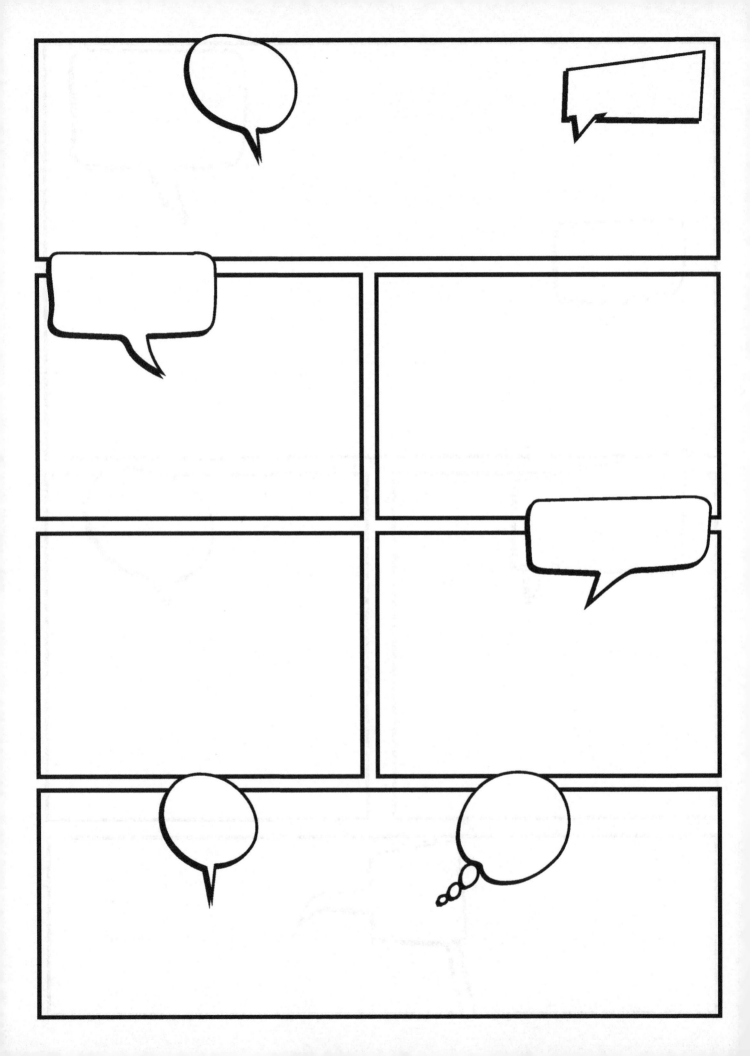

Our Books

Books For Kids (Coloring And Educational) Ages 1-4

Toddlers coloring book
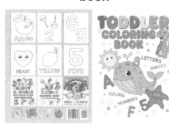

My first big and simple coloring book

100 Happy animals coloring

Dot markers activity book

Scissors skills activity book

Large ABC letters

Coloring Books For Kids Ages 4-8

Magical Unicorn coloring book

Fantasy kingdom for boys

Fantasy kingdom for girls

Dinosaurs and things that go

Cute mermaids

Dinosaurs coloring book

Our Books

Word Search Puzzle Books For Kids Ages 6-12

word search book ages 6-8

word search puzzle Book For Kids Ages 8-12

Sudoku Book For Teens Adults And Seniors

Comic Books For Kids And Adults (Imagine And Create Your Own Stories)

Coloring Books For Teens And Adults

Soulful Sancuary

Soulful Sancuary

102 Mandalas

Enchanted Escape

100 Baby Animals

Blossom Buddies

Word Search Puzzle Books For Adults

Made in United States
Orlando, FL
23 November 2024